about
70
photographs

about 70 photographs

Edited by Chris Steele-Perkins Commentaries by Chris Steele-Perkins and William Messer

Arts Council of Great Britain

About 70 Photographs

Edited by Chris Steele-Perkins

© 1980 Arts Council of Great Britain
Introduction © Chris Steele-Perkins
Commentaries © Chris Steele-Perkins and William Messer
Acknowledgments appear opposite

Designed by Alan Stewart
Production Management by Travelling Light, London
Typesetting by Opus Photo, London
Printed by John S. Speight Ltd., Leeds
Distributed by A. Zwemmer Ltd., 26 Litchfield Street, London WC2H 9NJ

British Library Cataloguing in Publication Data
About 70 Photographs
 1. Arts Council of Great Britain
 2. Photography – Great Britain – History – 20th century
 3. Photography, Artistic – History – 20th century
 4. Steele-Perkins, Chris II. Messer, William III. Arts Council of Great Britain
 779'.0941 TR654

ISBN 0-7287-0209-6 Hard cover
ISBN 0-7287-0208-8 Soft cover

A list of Arts Council publications, including all exhibition catalogues in print, can be obtained from the Publications Department, Arts Council of Great Britain, 105 Piccadilly, London W1V 0AU

Notes for the Introduction are listed on page 145 and the text notes are on pages 145 to 147

Acknowledgments

We thank the following people for their help in the realisation of this book:
Nina Kelgren and David Hoffman for essential picture research;
Heather Forbes and Peter Turner who co-ordinated production;
Alan Stewart for the design;
Averil Ashfield who sub-edited the text;
Roy Kift, Richard Smith, Valerie Lloyd, Peter Turner, Colin Osman, David, Hoffman, Stevie Bezencenet and Mark Haworth-Booth for comment and criticism;
the Photography Committee of the Arts Council of Great Britain, David Hurn for providing the opportunity and especially Mark Haworth-Booth for having sufficient faith to support the idea from its conception;
Claus Henning, Director of General Exhibitions at the British Council, for timely enthusiasm and undertaking to produce an exhibition based on this book;
many friends and colleagues for their encouragement and suggestions;
each other, from whom we have learned appreciably.

There is also a generic debt, in kind and spirit, owed to numerous individuals for their influence and example prior to this book's conception. Along with those neglected by fuzzy memories, they are Mark Edwards, John Szarkowski, Nathan Lyons, Bill Jay, Bill Brandt, Robert Frank, Ralph Gibson, Larry Sultan, Mike Mandel and the photographers themselves, whose work provided stimulation and reward throughout our efforts to present it.

Chris Steele-Perkins and William Messer
March 1980, London

Introduction

The selection of photographs in this book is intended to delight, provoke, disturb, entertain and stimulate. The accompanying commentaries have been written to further such responses.

All these photographs are represented in the collection of the Arts Council of Great Britain, but they do not reflect the overall balance of that collection as many of them have been specifically purchased for this book from areas of practice previously outside the Arts Council's frame of reference. This is because a great deal of interesting photography is, and always has been, done by people who work outside the practice of art. Indeed it is precisely the inter-relationship between the functional and artistic traditions in photography that makes it such a vital and potent medium.

An examination of the history of photography reveals a curious avant garde of technology, artists and journeymen photographers. Technological advances such as miniature cameras, more sophisticated lenses, increasingly sensitive emulsions, colour films, instant development and electronic flash have continually opened up the medium for practising photographers. Its art history is studded with photographs and photographers innocent of artistic intention. Later they were 'recognised' and annexed to that history. The contribution of such photographers as John Thomson, Eadweard Muybridge, Eugene Atget, Jacob Riis, Jacques Henri Lartigue, Weegee, Robert Capa and Dr Harold Edgerton is enormous. Their initial motivations were many and various: scientific research, providing documentary illustrations for painters, social reform, childhood enthusiasm, and photographing for newspaper and magazine stories.

The importance of the functional tradition in photography was recognised and massively celebrated in the 1929 German exhibition, *Film und Foto*, a venture which filled 14 galleries. The director, Gustaf Stotz, stated at the time, 'the results that can be obtained uniquely by these new photographic means have been published here and there but never systematically compiled The fields that will be investigated are extensive. To name a few: news photographs in the widest sense including sports shots, war pictures, night exposures, criminological photographs. Further: scientific photographs–zoological, botanical, medical (X-rays)–photomicrographs, aerial views, studies of the structure of materials. Then the area of light made form-giving by artificial sources, some with lenses, others directly on light-sensitive paper (photograms); the superimposition of several photographs; the use of photography in the graphic arts and advertising (photomontage and phototypography).'[1] In addition to these images the work of well-known photographers, including Edward and Brett Weston, Man Ray, Moholy-Nagy, Edward Steichen, Charles Sheeler and John Heartfield was exhibited.

More recently it is in the USA that functional photography continues to be explored.

In 1966 John Szarkowski edited *The Photographer's Eye*[2] which investigated aesthetic values in photography by drawing upon an eclectic selection of photographs. In it he stated, 'The study of photographic

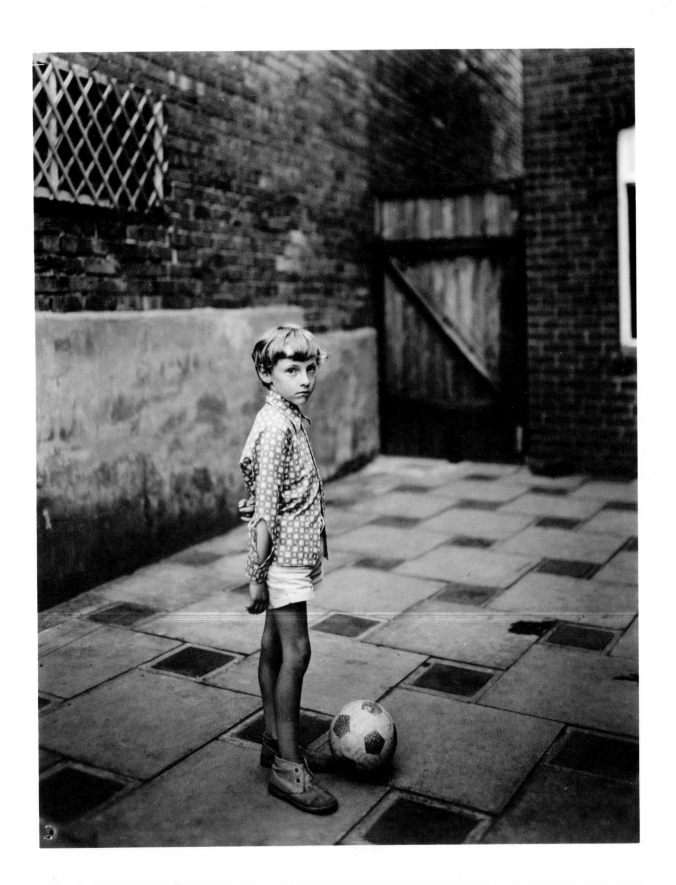

GEORGE COLE, ACTOR

George Cole is an actor and – as such – like a photograph. As an actor does, so must a photograph create a tangible, apparently recognizable representation of something apart from itself: this may be an idea, an emotion, a specific person, event or image. Its vehicles are imitation and illusion. Both the actor and the photographer perform, or attempt to, for an audience who may perceive them as anything from windows on to the world of actual appearances to mirrors of the playwright's or photographer's intended meaning.[1] One must believe in both their semblance and sense for their success, and one must be susceptible to some degree of confusion.

The celebrated American photographer, Richard Avedon, who has photographed many actors and models, once defined the photographic portrait as 'a picture of someone who knows he's being photographed'; continuing the analogy, the actor can be viewed as a photograph which knows it is being someone.

Just as the right photograph can appear to lend depth to an individual's character, the mirror provides confirmation of an actor's range. In the mirror the actor tests his mask. And should the rituals of transformation into and out of role after role, night after night, ever leave him confused and uncertain as to just who he might be, the actor can again make his passage to his dressing-room table to consult the mirror for evidence that all is well – he is himself, George Cole, actor.

BRIAN GRIFFIN 1977

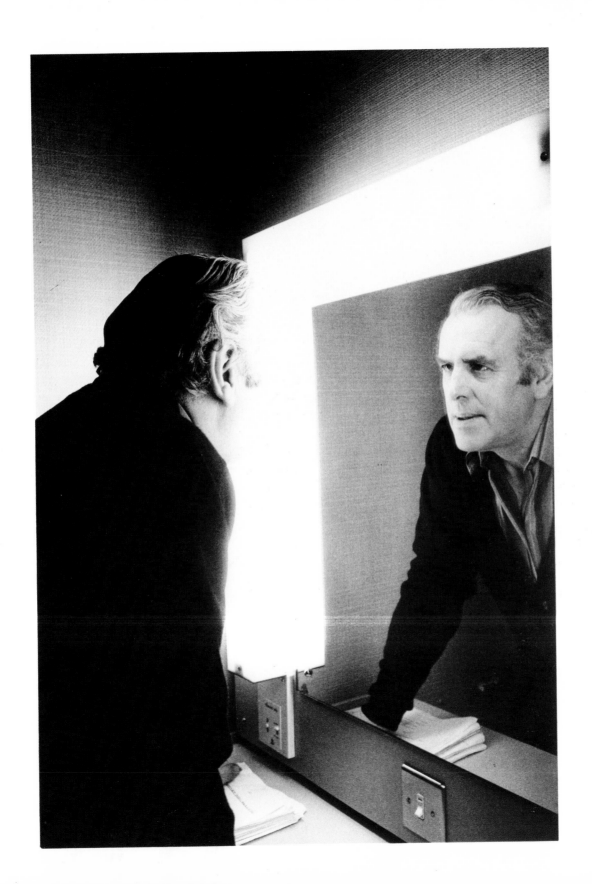

16 M.I.R.A. IMPACT RIG

Strange and marvellous events, scientific experiments. Facts. Photographic Proof! Transformational Mystery and mechanical theatre of the Conditional Probability Machine.[1] The IMPACT RIG! SEE the Truncated Silver Surfer forever suspended from rightful union with the Steering Wheel but what are we really shown?

 This is a publicity photograph made to demonstrate equipment for testing whether or not steering wheels are strong enough to meet safety standards – the illusion of forward movement was created by pulling the dummy backwards during a time-exposure. Knowing this in no way diminishes the photograph's impact.

ANDREW M. ANDERSON 1972

THE NICE, 'ELEGY'

As a picture, this is a landscape; as sculpture it is 'land art' or an 'earthwork'; as a commodity it is a record album cover for The Nice. The back cover continued the photograph to the left, so that the entire sleeve opened up as a panorama.

In this half, sixty plastic footballs proceed single file across the dunes of the Sahara. Why?

'The inspiration came from the music, late at night, and was a simple, spontaneous occurrence. The record evoked images of sparse landscapes. I imagined a desert but it felt too empty by itself and so was soon peppered with red balls, stretching as far as the eye could see, as if they covered the desert from end to end'.[1]

The balls have been placed with scarcely a trace of how they got there. This was managed by locating most of them along the craters' rims or on downward slopes so that footprints might be covered by collapsing sand, and by sporadic application of a brush. But as it's late in the only day available, there has not been time to clean up one flaw, deep in the picture, near the end of the line, marking the place where one of the two photographers was carried away by a Giant Auk. Not far from that spot there is a missing ball.

HIPGNOSIS 1971

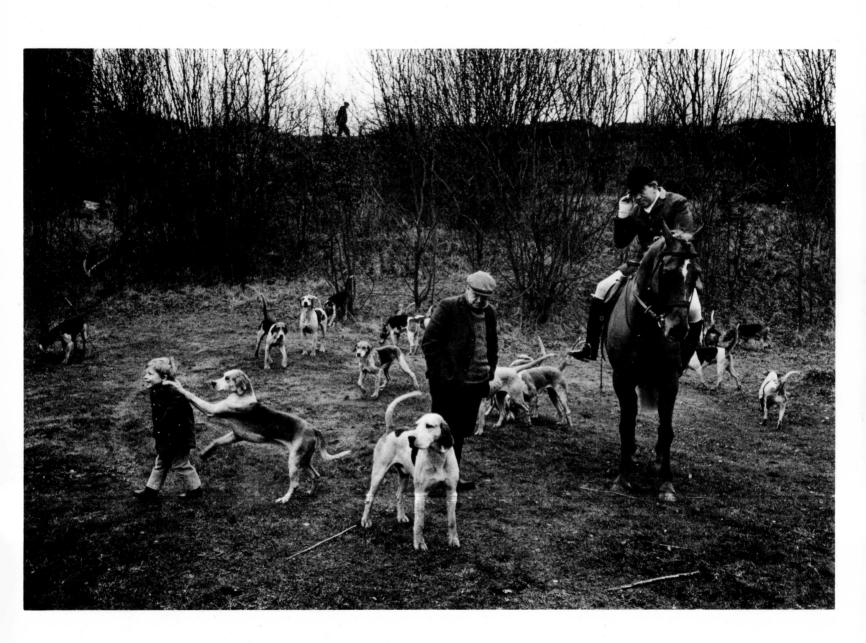

ELEMENTS

Within its unusually widened format, the panorama camera presents special problems of organizing the picture. Originally designed for landscapes and group portraits, it is more often used these days to produce gimmicky illusions and exaggerated effects. Paul Joyce employs the camera in older ways, with considered authority.

He presents an attractive and dramatically approachable picture. It can be read from the left or right or straight into the middle, traversed by high road or low, circumambulated through the hills beyond the lake or by following the sun towards the rainbow's end. And, upon returning home, it provides a comfortable space in which to settle. What more can you ask?

PAUL JOYCE 1976

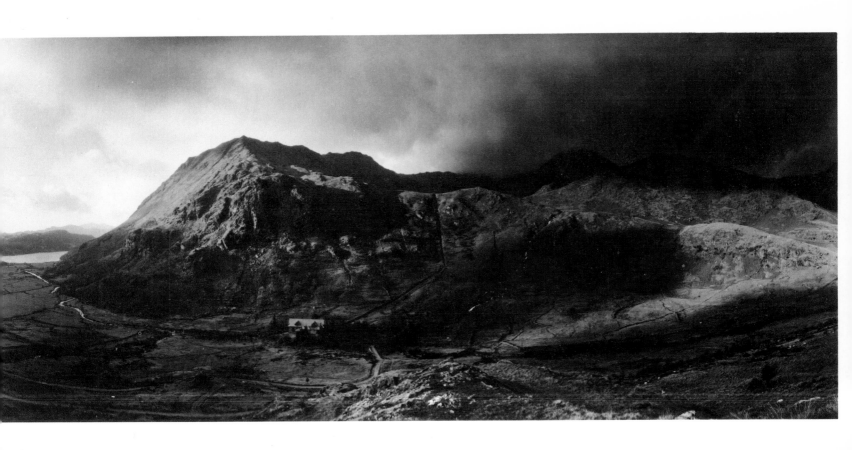

CATHY MORRISEY AND FAMILY

How much do we know about people merely from watching the way they sit, stand or move? Can we tell if they are happy, ambitious, intelligent, artistic, honest or sane? How much less are we accustomed to learning from their photographs?

You don't need the title to see that this is a family. Their feelings for one another are reflected in the comfort and openness of their touching – an intricate, human bonding both gentle and strong – as they share a blanket under a tree in a friend's back garden. They have come to London from a cottage in the Welsh countryside; life there was hard and they hope to find work and a new place to live in the city. Some of this is visible, in their clothing, in a slight uncertainty detectable in their faces and in the vulnerability and anomaly of their situation in the photograph.

Portraits are made for all sorts of reasons: simply for identification, as important records, to confer status, in insult, to lay bare the soul and just for fun. They may picture the notorious and powerful or the anonymous and lost, but in the good ones their subjects are no longer strangers.

The Morriseys did not find what they were seeking in the city and now Cathy and Tony and their daughters Poppy and Tasmin are living again in a cottage in the Welsh countryside. Their dog Bole has died.

BRUCE RAE 1979

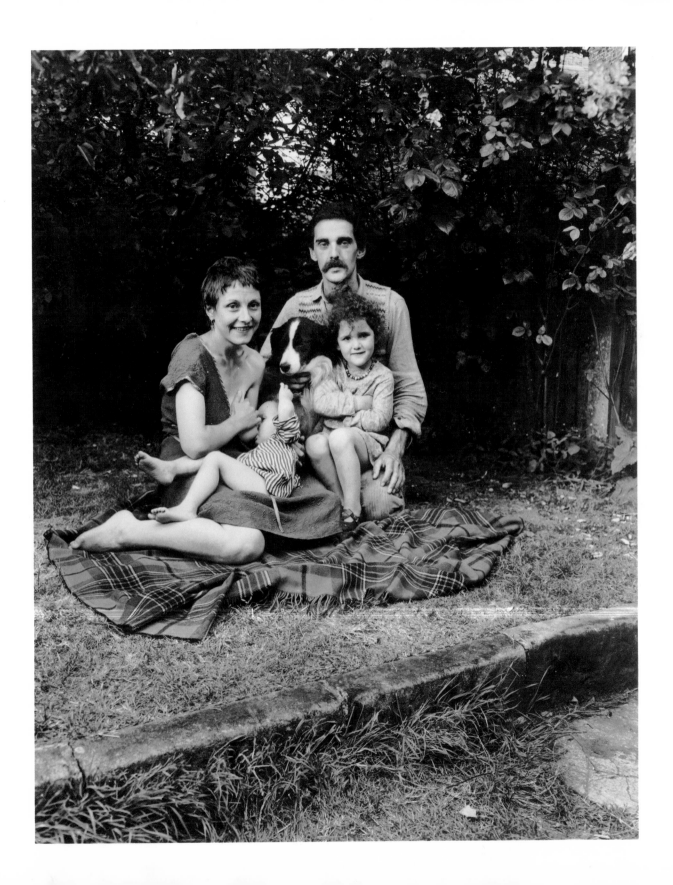

'STORMS CAUSE WIDESPREAD DAMAGE AND FLOODING IN THE SOUTH'

'Thunderstorms over the southern half of Britain early yesterday damaged homes, flooded roads, disrupted rail services, battered crops and made a dismal backdrop to the start of Royal Ascot . . .

A woman drowned when her car plunged into the swollen River Ouse at Bedford last night. Police divers recovered her body . . .

At Ascot course officials estimated that one and a half inches of rain had fallen in 36 hours. But the racing was on . . .

As the royal party drove along the course the wheels of their open landaus sank into the wet ground . . .

Officials ruled that Mrs Gertrude Shilling's Jubilee Year offering, a 3ft high by 6ft wide red, white and blue hat, was not suitable for the comfort and viewing of other race-goers. Mrs Shilling changed into a silver fox fur hat and coat and was then allowed into the Royal Enclosure . . .

In Ipswich a sausage factory on the outskirts of town which caught fire at the height of the storm is thought to have been struck by lightening . . .

A stack of paper pulp in Snodland near Rochester was struck by lightning and badly damaged by fire . . .'

From *The Times*, London, 15 June 1977

ANDY EARL 1977

THE BLACK HOUSE

There is no urgency here. It is ten past five in the Black House, a hostel for black youths who have been in some kind of trouble. Those who stay here come from court, prison, or have had a row with their parents. Some stay only a night or two; others keep coming back.

For many people hostel life is the start of a long slide into decline, loss of dignity, self-respect and meaning, if it isn't already the end of that trail. It can also be the first firm foot-hold in a shifting world. It is the intention of the Black House to provide stability and support in order to break the spiral of crime and imprisonment that leads from minor charges to hardened criminals. For many black youths their first encounter with the law is a charge of 'Suss', an application of the 1824 Vagrancy Act which allows the police to arrest someone merely on suspicion that they are likely to commit a crime. Such a law is readily abused and, in our prejudiced society, most frequently directed against blacks – in 1977, they made up 44% of all 'Suss' charges in London.

There is no information on the background of these two youths, but they appear not to have lost their self-respect. Their response to being photographed is neither hostile nor servile. They are quite smartly dressed and relaxed, sitting on a bare mattress in a bare room, facing a future that for sure holds no velvet lining. They look neither at each other or at us. This time is their time – time to just sit back in warming sunlight and ease into the sweet smoke and savour of an afternoon joint.

COLIN JONES 1978

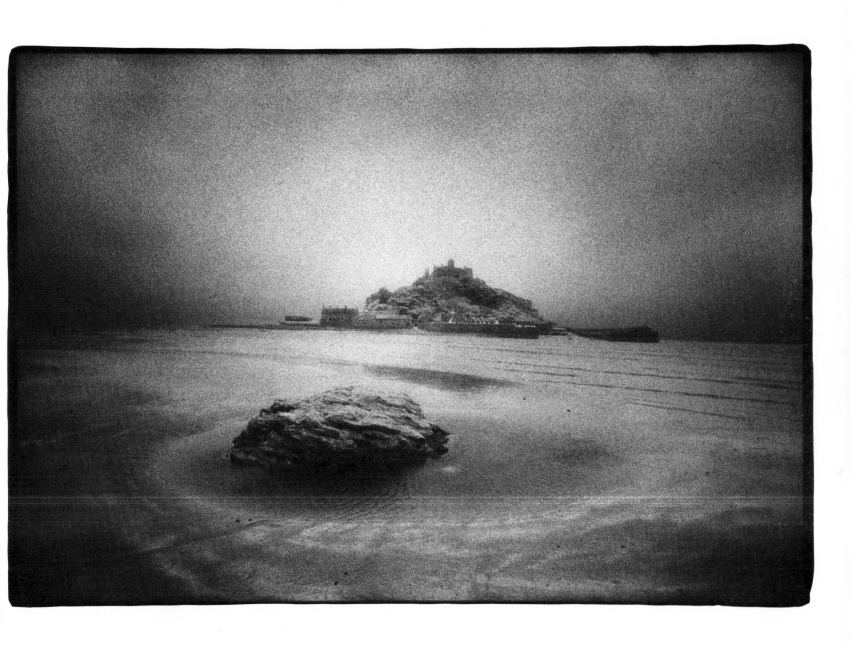

Photographs sometimes seem remarkably insubstantial when compared to the tasks they are asked to perform. Tiny, rarified and distilled images deposited on to comparatively fragile pieces of paper or plastic have been held responsible for our image of the world.

Mark Edwards spent two years in Christiania, a squatting 'free colony' on the outskirts of Copenhagen, and has published a book on the place. He began the project as a reportage photographer, but had to become a commentator and interviewer as well, realising that photographs alone were insufficient as a means of presenting the community in its entirety. The writing provides a history, biographies, reminiscences, analyses, fills in photographic blanks and speculates on Christiania's future; while the photographs describe the community, record its events, portray its people, serve to illustrate and expand the text and act as evidence. The book contains more than 400 photographs. Edwards points out that this represents no more than four seconds of real time into which two years must be compressed.

If 400 photographs are inadequate for a full documentation, how much more so is one? But being inadequate to this task, one can still be more than adequate as a singular record to be looked at and responded to. What can not be fully revealed can sometimes be implied, and the photograph may be as potent through what it excludes as for what is contained.

A strange, medieval ceremony is in progress, a mythical pageant set against a backdrop of low-slung bungalows and contemporary sameness. One individual, an apparently ordinary person, sits indifferent to its passage. This is one of Christiania's many processions which have become its major art form.

The photograph represents two realities distinct from itself: the external world and the intuitive responses, emotions and understandings of the photographer must both come together in a significant and convincing manner – the fullness of an individual's experience expressed in a handful of tonal fragments. It is an impossible task; yet, as with mining silver, or writing poetry, people continue to engage in the process of creating photographs in the belief that the concentrated result can be of disproportionate value to its means.

A good reportage photograph is expected to record and transmit information accurately, but this need not be a static, closed event. If the two realities of the 'objective' and 'subjective' world come together effectively, what is seen does not just mentally register, but reverberates in our imagination and memory.

MARK EDWARDS 1977

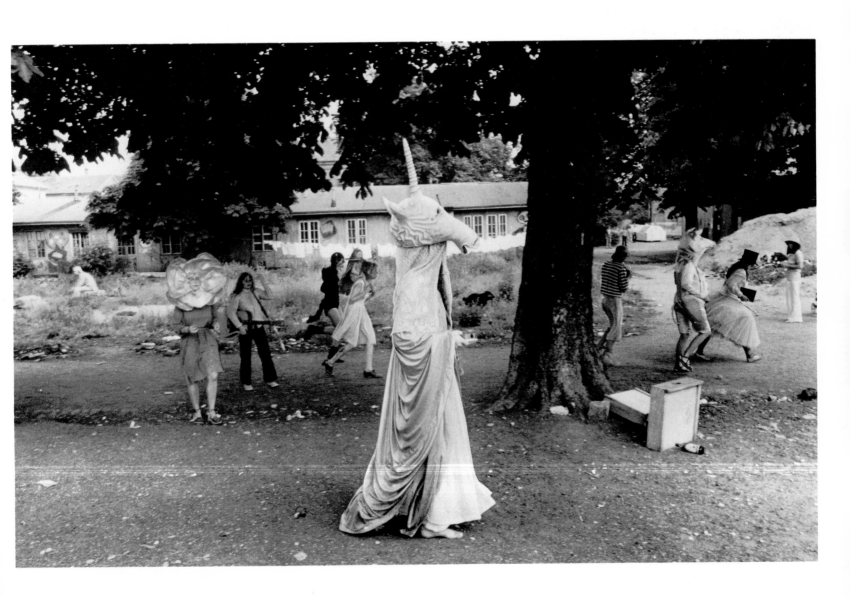

THE GHOST OF ST IA

So, what d'ya make of this?
Very 'English', I'd say.
Tripping!

Do you think he's off the ground?
It
What?
'it's'
. . . Just.

One thing that interests my head is how that acts as a shadow.

Miles from Heartfield.
And Ernst?
'Ariel'.
What?
Shakespeare . . . biological, like Tide.
Tide's not biological.

It's not very deep.
Doesn't have to be
Yeah, well . . .

Did you do that?
What?
Open your sandwiches?
Eh?
Crack an egg?
I don't know what you're talking about.
No? . . . must be the fridge.

ANDREW LANYON 1966

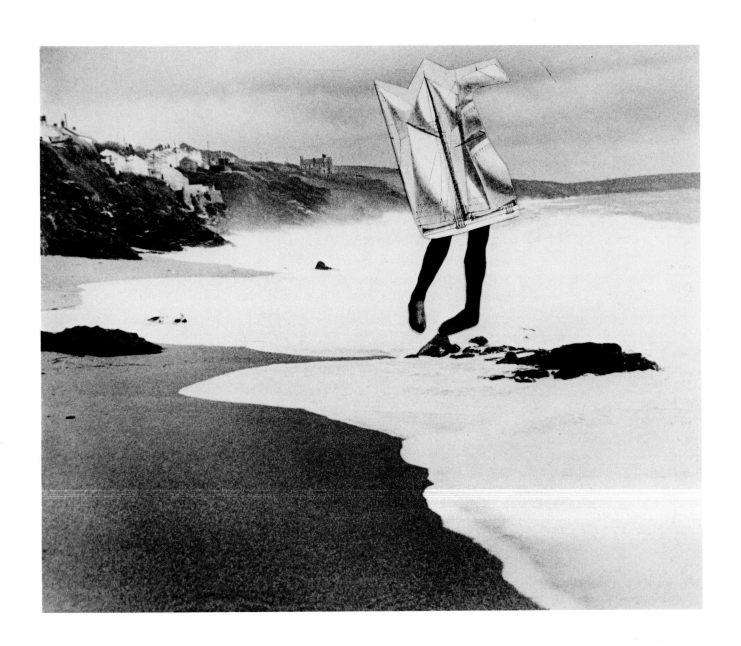

62 CAUSE OF DEATH

This picture demonstrates how framing affects the way a photograph is read and how captioning spells out its meaning – offering elegant forensic evidence that, although the camera cannot lie, photographs tell different truths.

JOHN HILLIARD 1974

CRUSHED

DROWNED

BURNED

FELL

Photographs are readily seen as being about the subject matter photographed and the power of their peculiar representational system is so strong that – inevitably – they are, whatever else they might be.

The system operates through a range of formal conventions, some inherited and some unique, including linear and aerial perspective, tonal gradation and density (highlight and shadow), variable focus, exact proportional relationships and a wealth of informational detail. They help create a formal language for photography with more persuasive capability than that of previous picture-making systems. Re-arranging or re-emphasising these conventions can suggest or even force alternative understandings from ordinary objects and events. Such manipulations occur throughout the medium and have been regarded as anything from eloquence to lying.

One way to understand this process is in terms of form and content. New information is produced in photographs either through the recording of new subject matter or the utilization of new formal structure. Each, acting upon the other, results in new meaning and can be perceived as creative. Most public photographs function in the first way, relying on relatively standardised forms to promote their various 'new' products, personalities, places, events, etc. While the history of 'art photography' has been based upon a search for innovative form in which to present traditional subjects – greater artistic recognition being conferred more often upon new ways of seeing than on new things seen.

Paul Hill's picture does not present sensationally new subject matter: in fact, it is all quite familiar – legs, rock, road, houses, trees. But the way in which these elements are combined is not so familiar. The scale, framing and vertiginous view-point are confusing, their intended meanings deliberately ambiguous. The legs, amputated from their identifying owner, seem to be a young girl's, her strapped on shoes protruding beyond the large, arm-chair like rock. Below them the road twists through a dark valley, past the end of the village; while, just below the road something that looks like the sea laps away at the picture's edge. In an elegant arrangement, the formal relationships of these objects and their roles in the fabrication of meaning are the photograph's *subject*, the objects themselves its *subject matter*. It is only through both that the photograph's real meaning can be found, invented or inferred from the possibilities provided.

PAUL HILL 1975

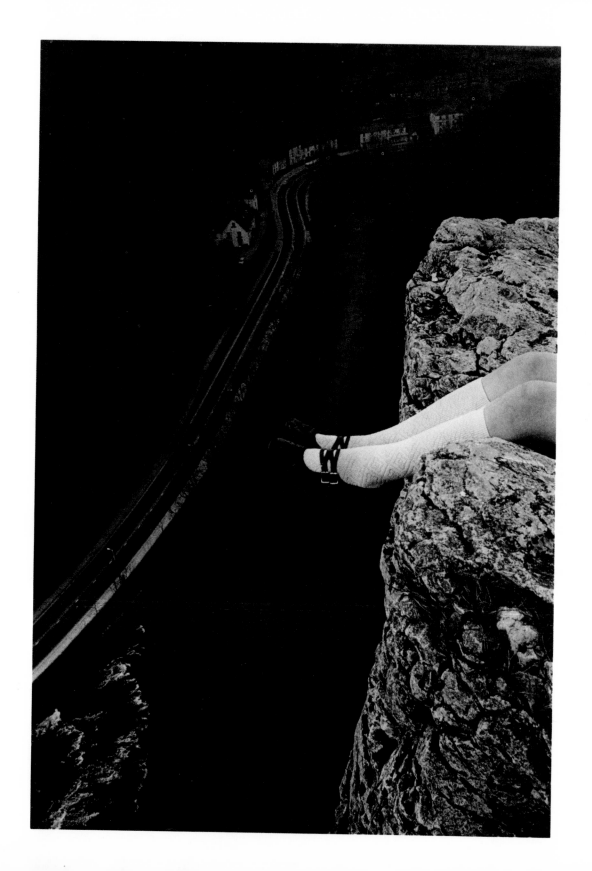

In some East European countries it is customary to observe a moment of silence and stillness before departing on a major journey. It is unlikely that the child here has made or will actually undertake such a journey – except in her imagination as a magical English adventure into which we are invited through the moment of exposure when these possibilities are briefly opened.

BRIAN ALTERIO 1976

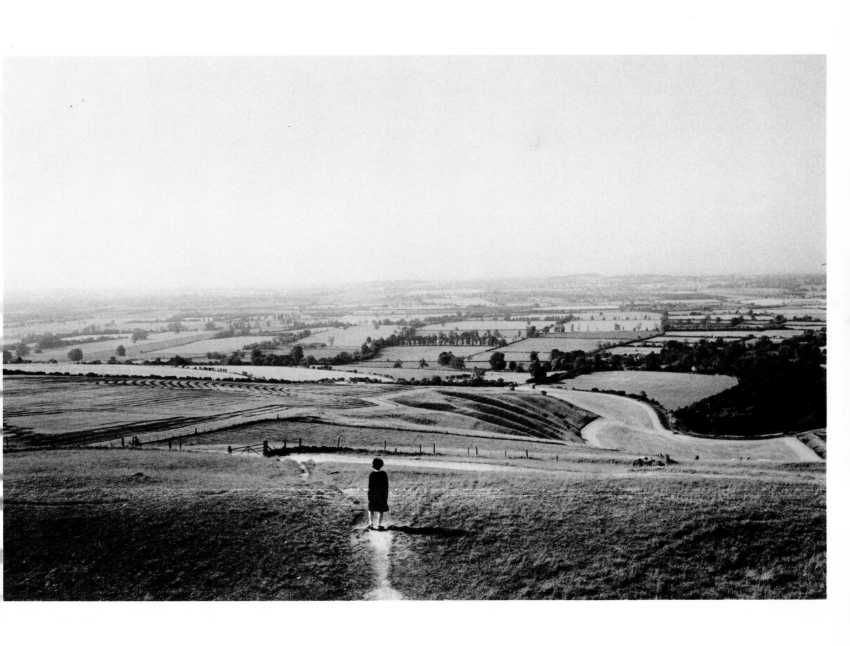

68 JEAN RHYS

From the early 1930s Bill Brandt's work has spanned the social documentation of London and the North of England and the pervasive class structure, industrial and ancient landscapes, environmental portraits of artists and writers, dramatic and abstract nudes, human and natural detail. The work's diversity has not affected its consistency, displaying Brandt's special mastery of form and space, strong tonal contrasts and an evocative sense of drama and melancholy.

Throughout his remarkable career Bill Brandt has continued to work as a magazine portrait photographer. His vision is still clear and his sensibilities sharp. He uses his special skills here, gently and certainly, in an old man's picture of an old lady.

This portrait of the author Jean Rhys was made for the *New York Times Magazine* when she was living alone in a cottage in Devon.

BILL BRANDT 1975

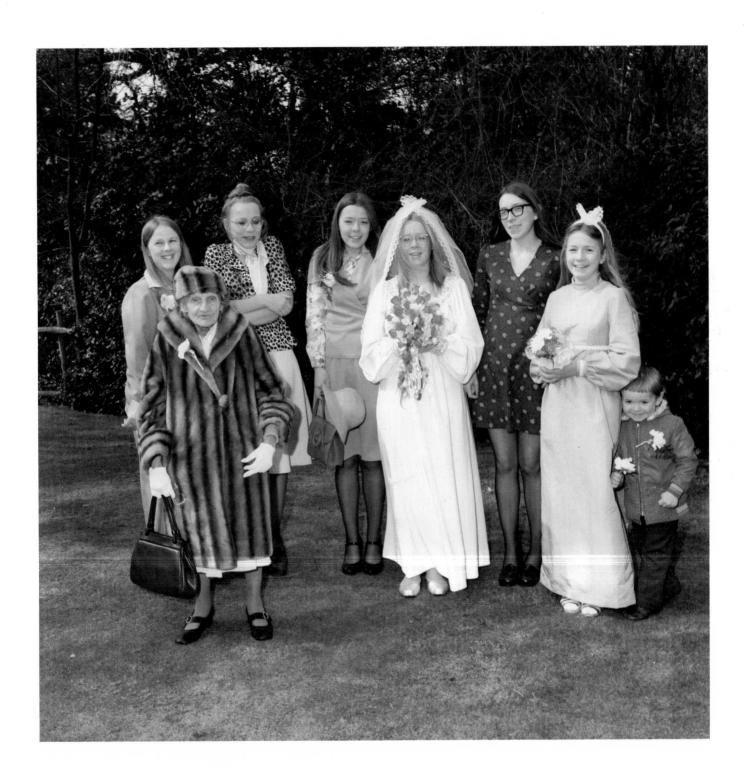

Traditionally communities have been photographed by outsiders moving in on an area, be it a Spanish village or a London slum, working there for a while and moving on, taking their photographs with them to show the rest of the world.

The Community Photography movement, which has developed so rapidly over the last few years in Britain, may be broadly characterized as an attempt to use photography within and for the benefit of the community. Motives vary widely, from wanting to encourage people to photograph friends, family and their environment as this '. . . provides immediate feedback for discussion . . . aids storytelling and reading, and makes it possible to look at the world differently; people can discover how to relate to themselves and each other more positively. . . .',[1] to a wish 'to turn the *objects* of conventional social documentary photography into agitators for change'.[2] Community photography can also be seen as a service, providing people with access to the medium, much as they have access to libraries, laundrettes and sports facilities. The differences in approach are many.

Ultimately the label of Community Photography is misleading, as it suggests a unity of thought and action and a concept of community which do not actually exist. Its emergence was essential, however, to focus attention on the need to make photography available to people who usually do not have such opportunity.

The socially orientated magazine *Camerawork* features this photograph on the cover of an issue subtitled 'Photography in the Community.' It was more or less taken by one of a group of children aged between 7 and 16 during an intensive one-day session organized by a community arts team. Those who opted for photography went off with cameras in the morning, developed the film at lunch-time and made or received their prints in the afternoon – a somewhat hectic affair which was repeated elsewhere with other unsuspecting kids on different days. Whatever the long-term benefits of such activity may be for the community, clearly (even though a camera might go wrong) this family derived at least one photograph and a great deal of enjoyment from the process, and both results have much to recommend them.

VICKY LACK 1978

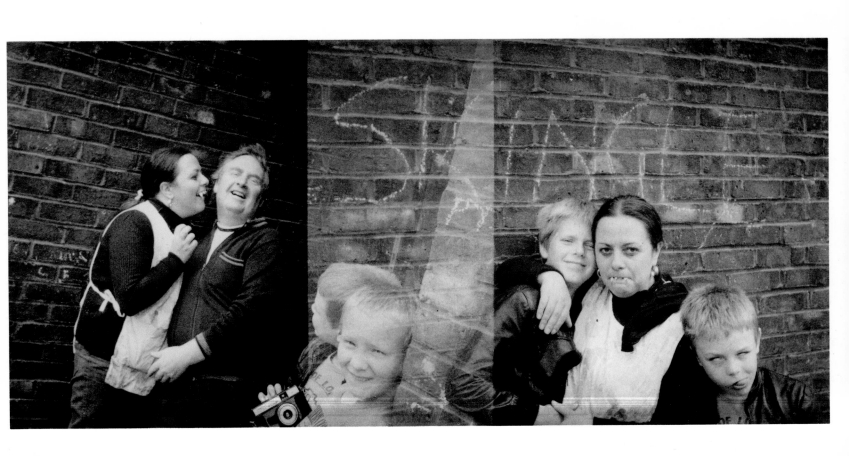

4-DIMENSIONAL MEASUREMENT BY PHOTOGRAPHY

This picture was made for an orthodontist as part of a five-year research project to enable accurate serial measurement of children's facial growth. It has been extracted from a record of twenty-five pairs of twins of like sex photographed at yearly intervals (hence, '4-Dimensional Measurement'). Twins were chosen to provide comparative studies between children born at the same time to the same parents and brought up in the same environment. The information derived from these studies is used to decide the most appropriate periods to apply orthodontic treatment.

The top pairs of photographs of the girls' faces were made by a specialized stereoscopic camera. When combined, each provide information of depth (in the way binocular vision provides us with depth perception) to be decoded by a computer into two-dimensional, two millimeter interval contour maps – as precise and distinct as fingerprints. Then, in the same way as architects build up site models from their plans, these maps were translated into three-dimensional models by form-cutting sets of two millimeter thick sheets of high density polyurethane to the same outlines as the contour plots and stacking the forms sequentially. These models were then photographed and combined with the previous recordings to produce the finished photographic document seen here.

Although it is a complex image, involving a multiplicity of visual and technical processes placed within a rigorous comparative framework, the photograph's formal concerns are non-aesthetic. It was produced solely in pursuit of stwait theeth.

L. F. H. BEARD 1976

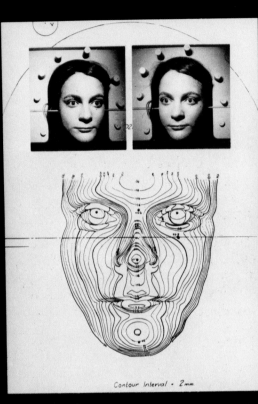
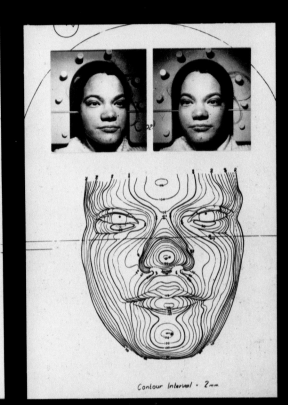

Contour Interval - 2mm

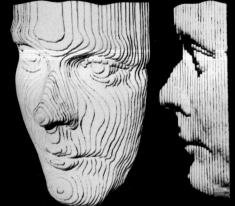

Many photographers approach the landscape with a concern to embody in a single photograph their unique experience of a place, celebrating *a* moment as *the* moment.

Phillippa Ecobichon is also concerned with place – her identical framing insists that we recognise the same field, photographed from the same position. Side by side, the images echo each other, neither taking precedence. Our attention is drawn towards a cataloguing of the differing detail between the photographs, in consideration of the natural progressions of change. Rather than being a single photographic moment, time itself becomes a formal element and subject of the work.

Ecobichon's photography is a more preconceived than a spontaneous response to the landscape which blends picture and process, each as a vehicle for revealing the other.

PHILLIPPA ECOBICHON 1977

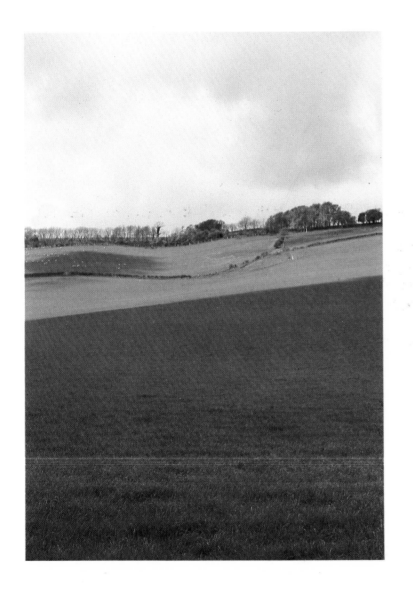
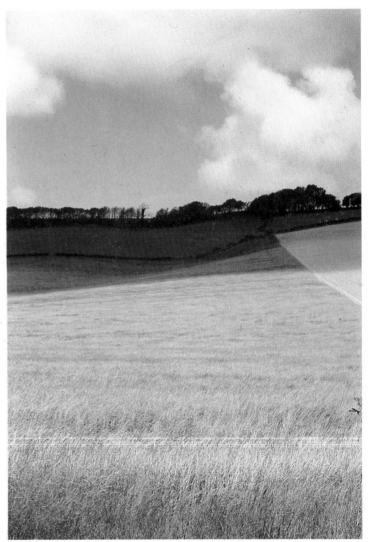

PASSING NATURALISTS

An official outing of the Surrey Bird Club is both an occasion and an adventure, which may result in a full-scale expedition, as has this one to Pagham Harbour in neighbouring Sussex. Besides avid ornithologists such an event is likely to 'pad out' with wives and husbands, even attracting Martin Parr and the odd naturalist.

Here are two serious specimens of the latter category thoroughly enjoying their pursuit of Nature. Both males, they are performing a ritual 'passing' in one of the tall grassy areas they love to trample. Making little attempt at camouflage they are easily identified by their distinctive knitted crown, large ears, sock-ringed rubber feet and the peculiarity of their bearing. The mature naturalist is distinguished by his pipe, walking stick and darker protective covering. Ordinarily gregarious, it is quite inadvisable to disturb this breed during outings as they are entering their most intense and unpredictable phase.

For best photographic results, combine long observation and high sensitivity with short shutter speeds and a touch of eccentricity.

MARTIN PARR 1974

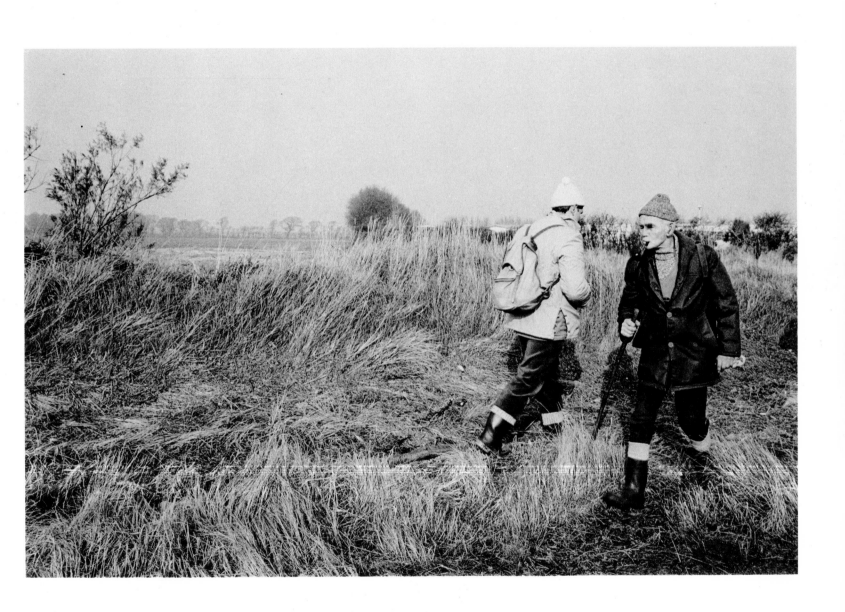

82 UNTITLED

This picture of Helen McQuillan's is an open book. The language in which it is inscribed is one of private symbolism expressed through carefully chosen objects. It refers to the processes of change and decay, familiar and alien forms, notions of beauty and ugliness and the varying identities of actual and apparent, artificial and real in photographic representation. Silver is visible as a rock, shrivelled fruit, crumpled paper, a cake-cup and the effect of light on a page. Red is a rose and similarly a radish. A rotted lemon has acquired a hue to echo and blend with the supporting page. Decomposing vegetables offer letters, words. Organic and inorganic materials restate each other interchangeably.

The photograph appears originally as a 5″ x 4″ transparency in a heavy, secretive, leather-bound book of Helen McQuillan's colour photographs. There it performs through a window on a detachable card set against a white backing between pages of alternating colour and pattern, across which references and allusions feed back and forth from image to image – serving as a unique book within a book. Removed, it can be viewed in different positions against differing backgrounds, its plastic pages again transparent. Reproduced here, it is returned to the fixed page, reflective, complete: an open book in an open book.

HELEN McQUILLAN 1976

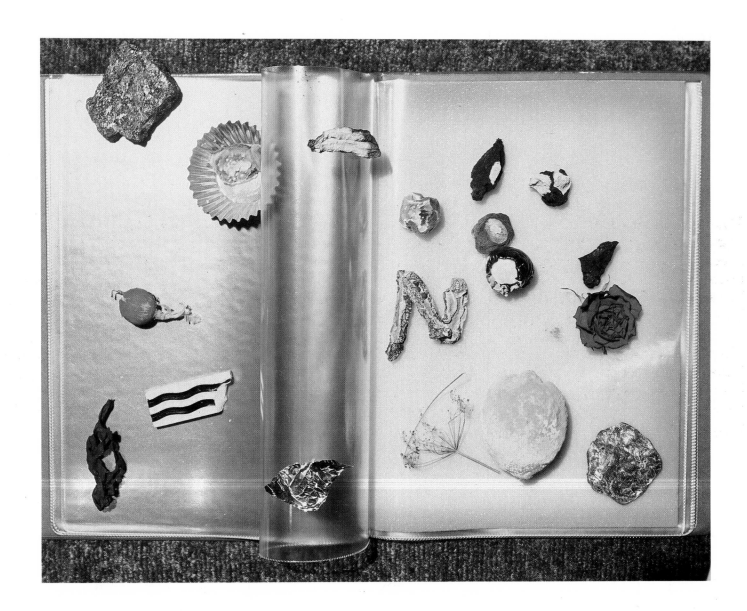

This photograph was taken simply to demonstrate this particular technique.

DEPARTMENT OF MEDICAL ILLUSTRATION, ST BARTHOLOMEW'S HOSPITAL, LONDON

The technique of assembling a photographic still-life has parallels with stage managing a photographic tableau, arranging the elements of a montage, producing a gallery installation or making a photographic book. Objects are chosen and arranged for their private, symbolic or visual meaning.

The Czech photographer Josef Sudek, who died in 1976, frequently constructed elaborate still-lifes, collecting together classical subject matter (fruits, shells, glasses, spheres) in conjunction with more personal items such as letters or gifts and juxtaposing them with eloquent ambiguity. He worked with a large-format camera, often making prints, which are soft by conventional standards, and occasionally leaving any dust marks and blemishes to emphasize that what he was producing was a new object – a photograph – not solely a representational record of his subject matter.

Sharon Kivland's picture ignores all the conventions of 'fine photography.' She employs none of the classical allusions of Sudek (though utilizing items of mixed association and discernibility); her acknowledged influences have been painters rather than photographers. Her fuzzy, emotive, informally framed, Instamatic close-up vision is better suited to a memory than a record. Indistinct, incomplete and nostalgic, yet instantly retrievable, her image is a souvenir, where the Eiffel Tower flows out from its candy-coloured wrap and the Champs Elysées inadvertently heads north to the sound of 'I love Paris' on a penny-whistle.

SHARON KIVLAND 1978

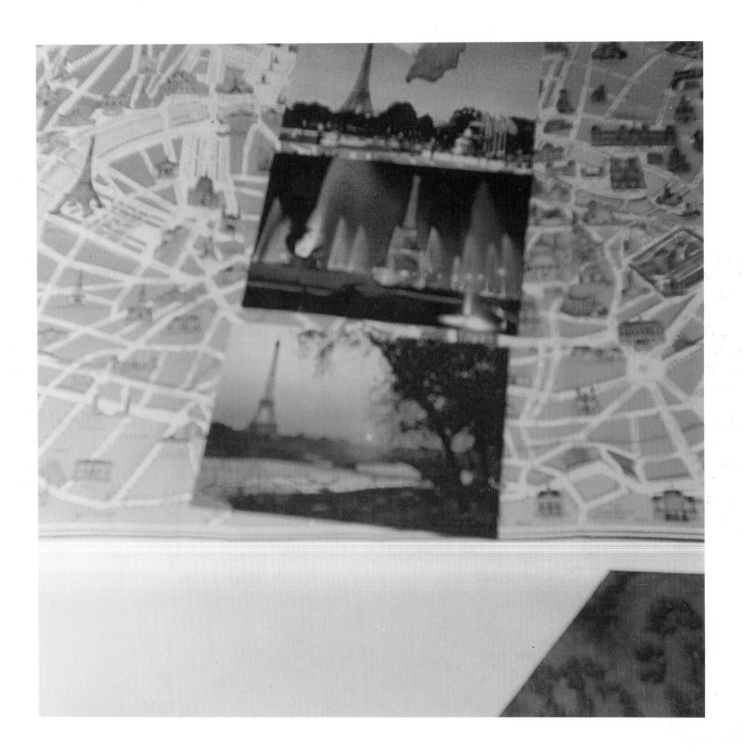

Having spent so much of his life abroad, Ian Berry was in 'the odd situation of being English and knowing very little about England' – so he set about rediscovering his native country as a professional reportage photographer.

The England that Berry rediscovered is a world of grey skies over grey landscapes, ageing urban environments and the ageing institutions of class. This photograph, however, has more to do with a generation than a country.

As a phenomenon that occurred in Britain as well as elsewhere, the open-air pop festival was a symbol of the 1960s 'alternative' youth culture that carried over into the 1970s. It was a movement characterized by anarchistic idealism and personal freedom of expression. Music was its voice, marijuana and L.S.D. its sacraments, and the pop festival its pre-eminent mass ritual.

This is London's Hyde Park. A young man and two women press against the fence at the edge of the crowd. The moment is rich with ambiguity, the photograph charged with speculative and symbolic notions. Two women, two ways of life; the man is between them. One, seemingly more insecure, reaches to him, held in place both by his arm and her own romantic intention; the other moves away independently and must be reclaimed sexually. Her face suggests a kind of pleasure/pain. The man seems emotionally detached, an impassive haloed figure as the archetypal male.

What is actually happening is not known to us. The relationships are unclear and the outcome unavailable. We know only that the event occurred by the fence at the edge of a crowd, in Hyde Park. But instead of Ian Berry merely showing us another fact about England which we already knew – that pop festivals took place – he has looked carefully, revealing more.

IAN BERRY 1978

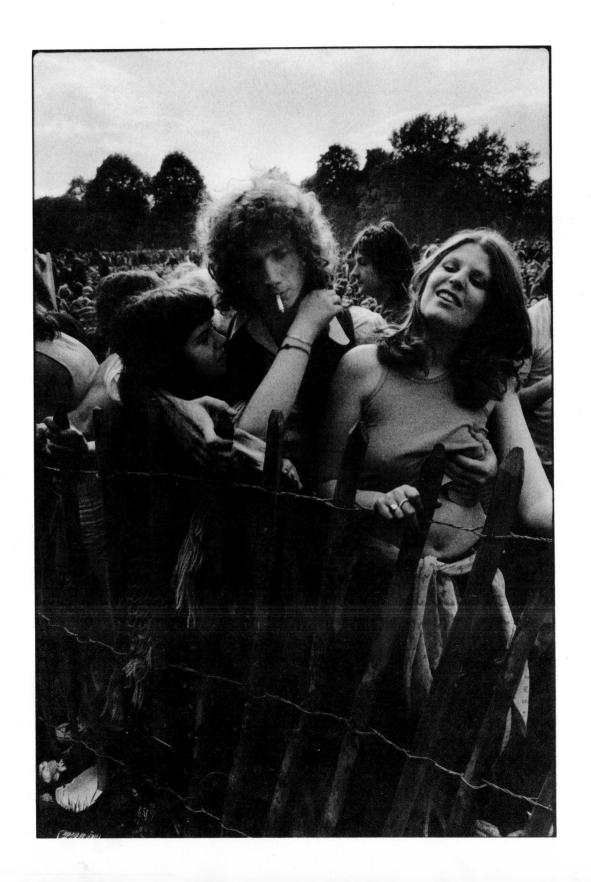

90 'M.C.P.'[1]

Cole Joseph is a taxi-driver. He lives in the old East End of London and as a hobby photographs its streets and the people working there. He uses an Instamatic camera and when necessary a flash-cube. The results can be brutally direct. His interests are primarily those of a collector, visiting places, snapping and filing away the chemist's prints in photo-albums as personal acquisitions. Joseph has little interest in exhibiting his photographs, but some were included in an exhibition at the Whitechapel Art Gallery in 1977 presenting different aspects of work and life in that area.

A number of people of differing sensitivity have photographed in abattoirs, butcher's shops and meat markets, but rarely do they produce work which so effectively throws up disturbing associations around the sinister activity of slaughter and dismemberment – a process transforming animals into meat, and suggesting the possibility that we are what we eat.

COLE JOSEPH 1975

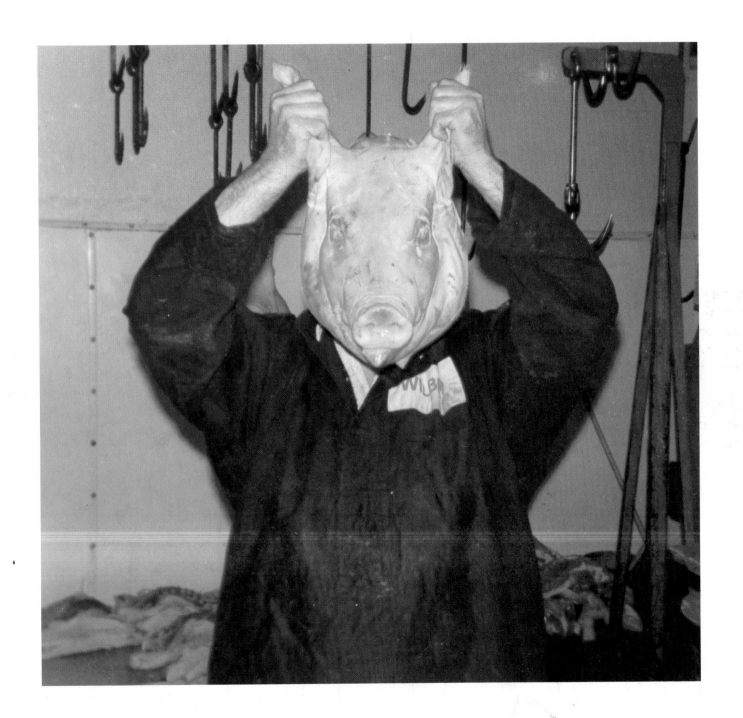

PINNER FAIR, MIDDLESEX

This photograph was taken at Pinner Fair, an event decreed by Edward III to take place twice a year: to celebrate the
Nativity of St. John (1-3 June), and 'on the day and morrow of the decolation [beheading] of St. John the Baptist'
(29-30 August). Originally a market for the exchange of cattle and produce, it has now developed into a pleasure fair
which takes place in the High Street on Whit Wednesday.

Pictured is one of those situations where you pay to step inside a sideshow tent and watch ample women dance
naked, before passing on to shy wooden balls at coconuts and win diminished goldfish in plastic, see-through bags. The
master of ceremonies, in dinner jacket and bow-tie, has just drawn back the curtain to reveal his performers. All eyes are
on them: including those of a decolated Humphrey Bogart and, of course, our own – voyeurs too.

HOMER SYKES 1971

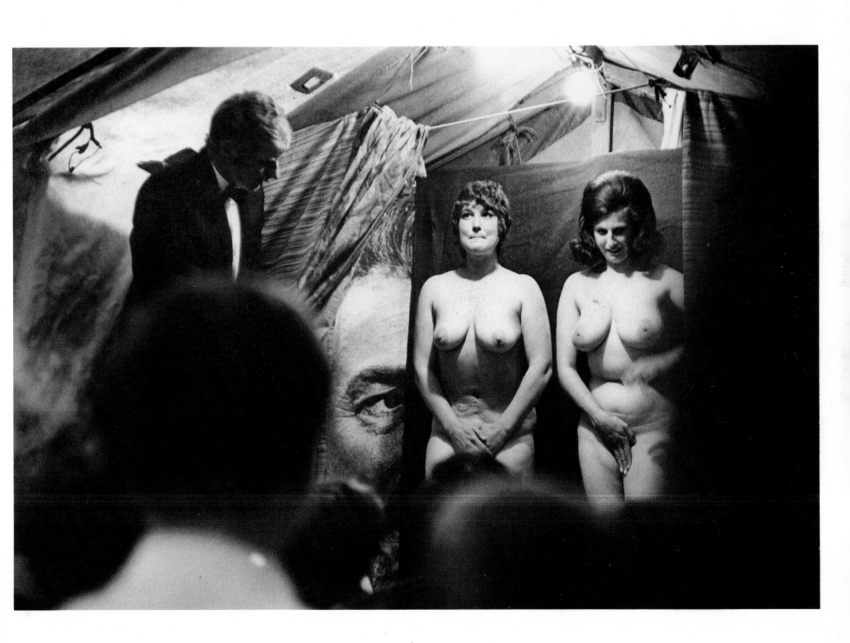

94 UNCLE CYRIL ARRIVING FOR TEA

Auntie Emma may be a bit fruity but it seems Uncle Cyril takes the biscuit. Grinning back at us from atop his BSA, he may well be saying he knows.

 Michael Bennett made this series of montaged portraits as part of a whimsical exhibition in appreciation of his own family and once presented it at Brent Cross Shopping Centre.

MICHAEL BENNETT 1975

FAMILY SELF PORTRAIT

Most people use their cameras to record their family, friends, baby's birthday party, weddings, Christmas and holidays – the people and occasions closest to them. Many prominent photographers feature family members either in portraits or as models; yet it seems remarkably few professional reportage photographers attempt to photograph in detail their own daily lives and that of their immediate family, preferring instead to photograph slices-of-life from less familiar situations. Possibly this reflects the pressure imposed by working professionally militating against photographing the family with the same vigour and the fact that doing so is unlikely to be financially rewarding, since editors and publishers have not considered such personal work to be important. There is also the problem of including the photographer naturalistically as an integral part of the family.

Richard and Sally Greenhill are both professional photographers who decided to document their family life. Towards this end they rigged up a permanent bounce flash unit in their living room and made use of a radio-controlled shutter release on a camera which could be triggered wherever it was set up. Their intention was to record themselves as candidly as possible. They first showed this work as an exhibition called 'Family Self Portrait' in 1977.

Their daughter Nell was born at home with the help of a midwife in order that the birth could be more freely photographed and so that their son Sam could be present at the delivery. They felt that if he understood the circumstances surrounding the appearance of his new sister he would be less jealous of her, and in addition he might enjoy the experience. During the actual birth Sam got excited . . . but that was 15 minutes ago.

RICHARD GREENHILL 1976

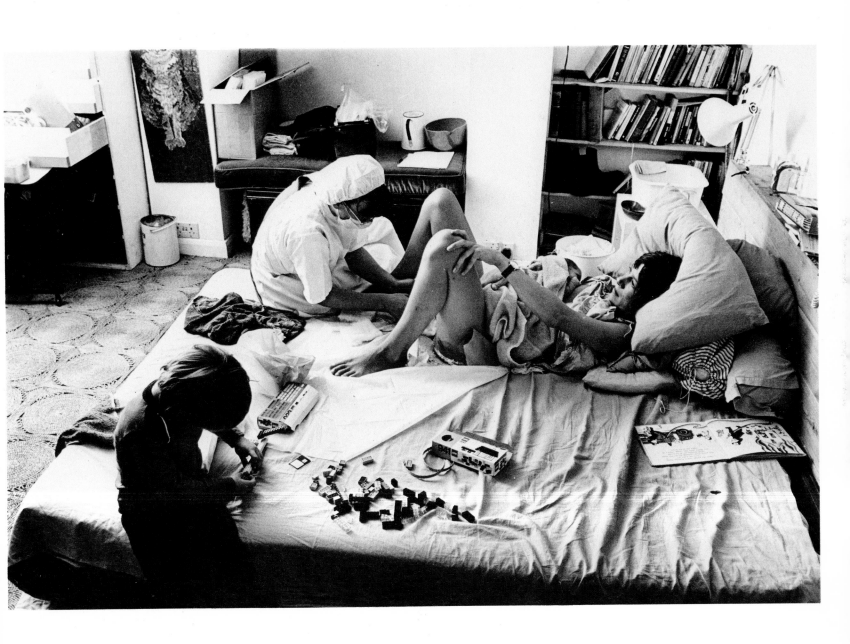

DESERT LOCUST IN FLIGHT *Schistocerca gregaria*

'This Desert Locust is in its darker migratory phase, ready to join with millions of its fellows and take off in search of greener pastures'.[1]

Like most scientific photographers before him, Stephen Dalton has had to develop the appropriate technology to achieve his particular purpose: to photograph with complete clarity insects in natural flight. This involved developing faster shutter speeds than any commercially available as well as an extremely powerful, short duration flash unit which could be triggered within one millionth of a second of a light beam being broken by an insect's motion. Such timing is necessary otherwise the insect would pass beyond the limited depth of field of the close-up lenses.

With the assistance of electronics scientist Ron Perkins, equipment was developed which could also record sequences. The photographs could then be used to study the changes in angle and movement of an insect's wings in free flight, a study necessary to determine how some insects fly in apparent violation of the principles of aerodynamics. Previously photographers had relied upon such unsatisfactory techniques as suspending the insect by thread.

Stephen Dalton's pictures represent an important breakthrough in the photographing of insects; they are also often astonishingly beautiful.

STEPHEN DALTON 1975

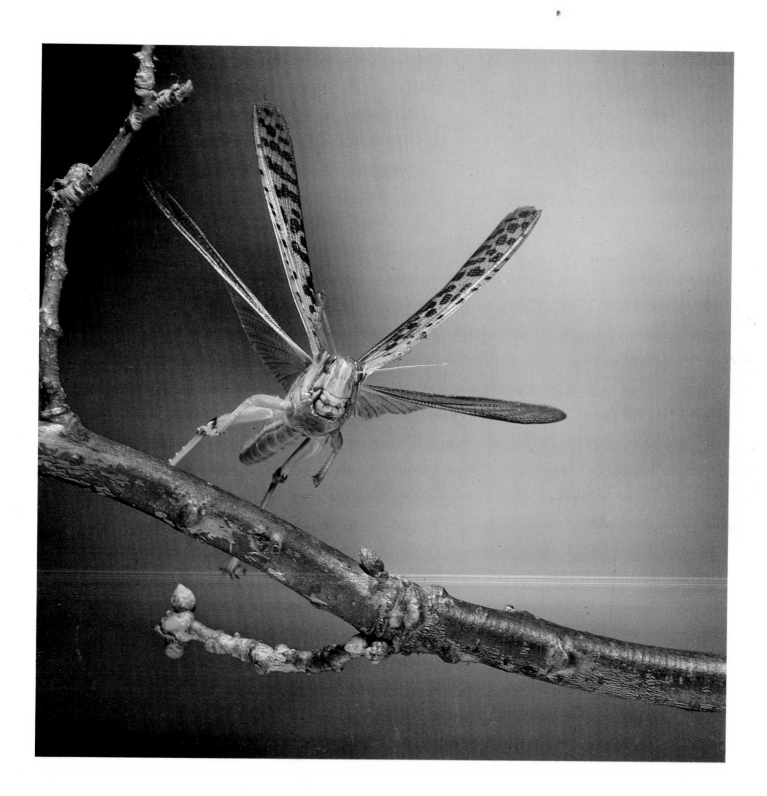

FIRE-EATER

Photographs all too frequently confirm predictable ways of seeing rather than advancing new ones. As with dossers, politicians, entertainers – indeed most sub-groups – stereotypes of people are easily adhered to. But when they are juggled, the effect can be potent.

Rolph Gobits plays on our expectations of show-business figures, with their associations of audience and role, glamour and lighting, costumes and smiles, by placing them in the mundane and professionally disassociated settings of private hallways and suburban living rooms.

Like an inversion of a tale of Cinderella having stayed too long at the ball, the costume remains but the surrounding splendour has vanished; the illusion stripped to its single human component, her theatre transformed for the photographer.

ROLPH GOBITS 1975

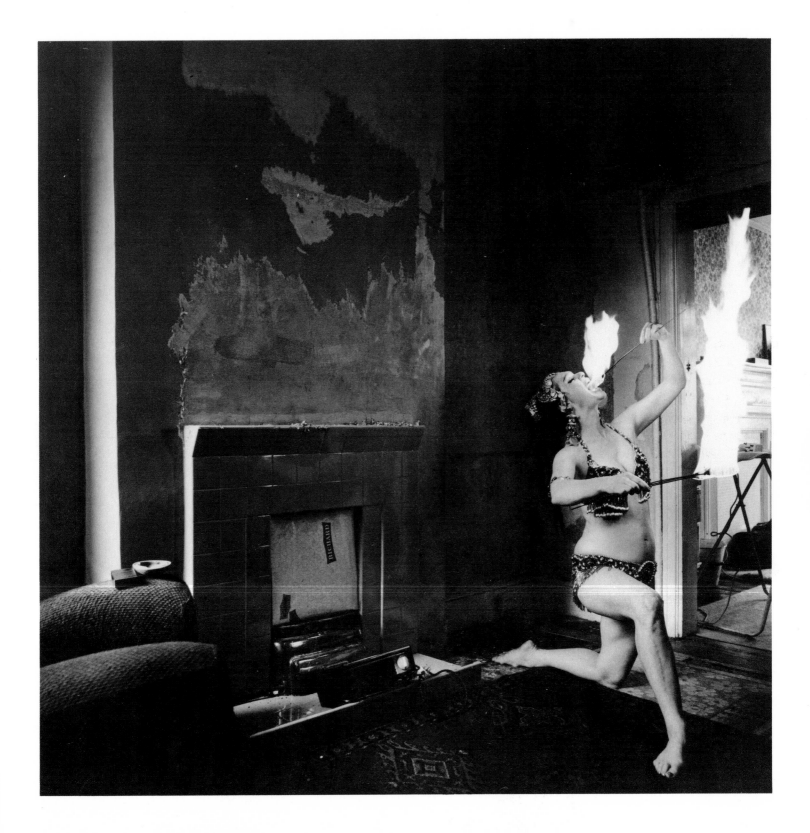

WHITE HORSE WHISKY

By virtually animating the name of the product and creating the slogan 'You can take a White Horse anywhere', the agency for the White Horse Whisky account opened up the possibility of a series of striking tableaux of sumptuous settings in which a white horse makes surreal, almost ethereal appearances while the actual product is discreetly displayed. As with the Benson and Hedges' cigarette advertisements (page 138) the product is first recognized through the campaign's imagery, which also employs ambiguity and visual illusion to enhance its impact. In this case the deep space of the photograph is created by the set's painted backdrop while the intended 'paintings' on the walls are sufficiently enigmatic for us to wonder if they are not in fact windows, beyond which float more ephemeral white horses. But the most significant illusion is the presumed fundamental relationship between the product and the lifestyle represented, wherein Beautiful People inhabit Exclusive Worlds with the help of White Horse Whisky – a rarified realm of the spirit offered to be stepped into by anxious aspirants.

There is as yet no advertisement in which a white horse peers serenely out from a toilet at drunken sailors brawling in a dockside bar, with the product discreetly displayed in a burly hand descending on a finely chiselled head.

PETER WEBB 1972-3

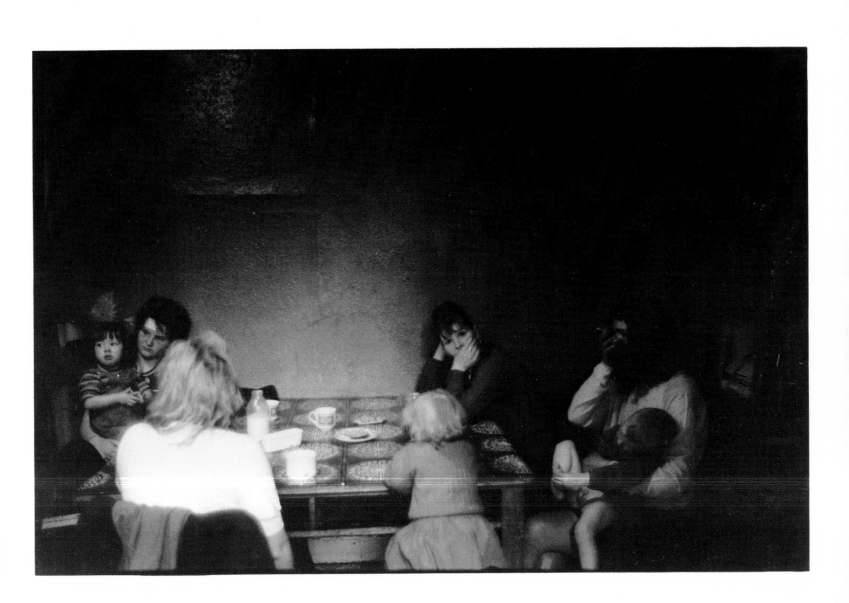

Women artists have a lot to say and many ways to say it that have not been possible before the major emergence of the Women's Movement of the 1970s. Feminism has provided a means of extending the issues, intentions, forms, subject matter – the nature of art itself. Its achievements could result in a radical shift in our awareness of what is valid or 'proper' territory not only for art, but for our attentions generally.

Annie Wright prefers not to be classified as a 'feminist artist', considering the label more restricting than enlightening. '. . . The "feminist art" I have seen in Britain has been openly polemical; in general, I don't think my work is, nor would I want it to be'. Regardless of this preference she has allowed herself to be presented as such, in sympathy with the role critic Lucy Lippard extends to feminist art of creating alternative ways of seeing beyond polemics. Wright also chooses not to call herself 'a photographer', but rather 'an artist using photography,' perpetuating cultural distinctions which are continually blurring and breaking down. This is done partly out of respect for the medium, acknowledging a lack of experience and expertise in photography formally, and partly in an attempt to avoid the prejudices and misconceptions that can still grow from expectations accompanying the photographer's stance in traditional fine art circles. But the work clearly exists as photographic prints, the final form she has found to be most effective for her ideas.

Annie Wright's title is a reference to the Freudian notion of the vagina as a 'wound' in the body of a woman's 'narcissism', caused by the absence of a penis.[1] The act of sewing itself is a natural, psychological, almost medical response to the large corporal gash through which her blood flows – an essential step in self-healing the psyche and attempting to prevent the 'scar' of 'a sense of inferiority' which Freud believed accompanies this awareness.

Wright's subject matter is herself:– 'My raison d'etre is being female, and all that implies in our society . . . I start a piece through some kind of basic impulse that makes itself clear in the process of making the piece. The sewing up was something I felt; I did not set out to illustrate Freud. It happened coincidentally . . .'

Her photograph combines a close intimacy of embroidery with the theatrical lighting of performance, and a stark, recordative black and whiteness, all translating her 'impulse' into a tangible reality. That which would normally flow out is now sealed in; and if fertilisation and impregnation have occurred . . . And if they have not . . . Unable to be strictly confined as woman's work, the piece has ramifications for its male viewers as well:– 'Feminism has given me a way of seeing things, analysing and realizing . . . I think the piece is about hiding, covering up and retreating – and, as has been pointed out to me, excluding'.

ANNIE WRIGHT 1979

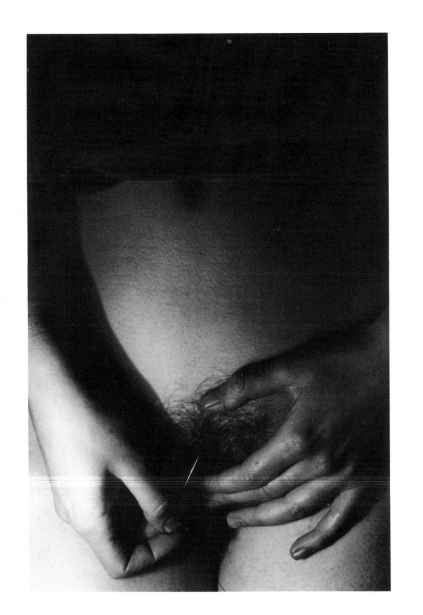
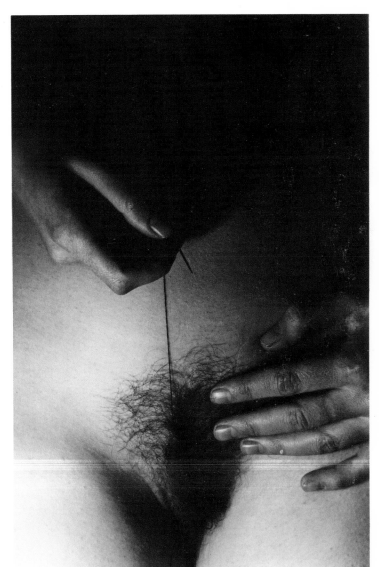

SALFORD

Many visual artists have been fascinated by devastation and ruin. Familiar forms become dramatically altered; dynamic forces are visibly expressed, often magnificently. The attraction is apparent, although sometimes the deeper drama of which these surfaces are evidence, the actual human meaning of the events which have transpired to achieve them, seems lost and forgotten in the beauty of the form.

But new forms, to be recognizable, must in some way echo the old and these traces can be poignant. Depth of meaning, almost by definition, will not be found brandished on the simple surface of things. Photographers need not always pay conspicuous or even conscious homage to the more directly political, social or emotional implications of their work; the photographer's role as artist in a culture carries its own social and political reverberations and a built-in emotional involvement. The act of creation from destruction is itself one sort of homage.

MARTIN ROBERTS 1975

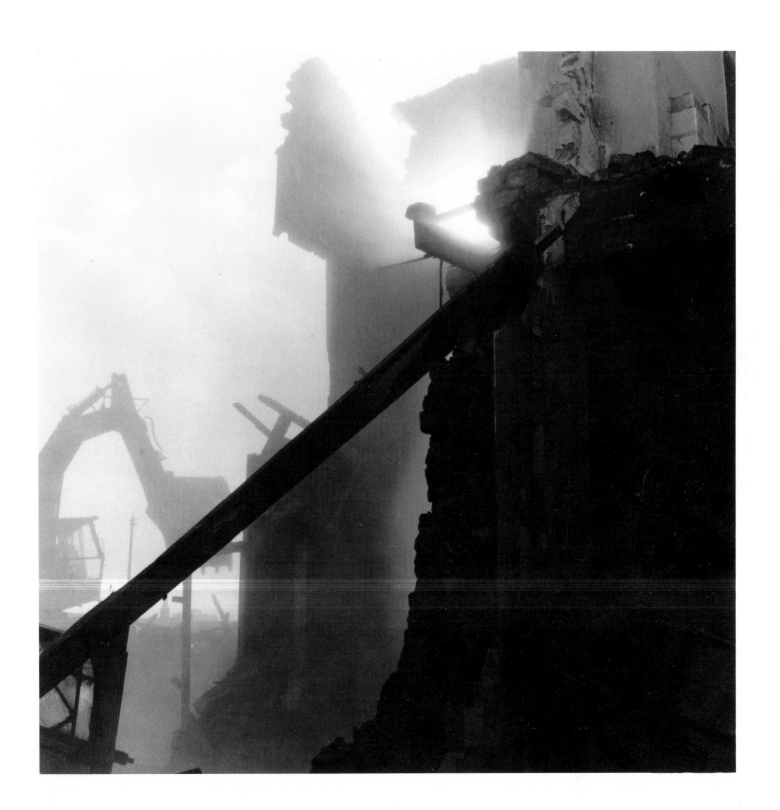

THE ABBEY, BURY ST. EDMUNDS

The Abbey at Bury St. Edmunds started life in 633 A.D. as a small community of secular priests, replaced in 1020 by twenty Benedictine monks on the orders of King Canute. Later its privileges and numbers were increased by William the Conqueror and it became one of the most powerful Benedictine monastries in Britain. Today, apart from two mighty gates into the precinct, all that remain are 'fragments, which tell their tale only to the student'.[1]

The place has become a popular stop for tourists. Countless postcards describe it. Untold numbers of Instamatics full of Kodachrome 64 have photographed it. Yet it seems unlikely that in any of those photographs it has ever looked quite like this.

It is a curious image, quite beautiful really, with amorphous stumps of crumbling stonework and a looming laval pillar liquefying in raking sunlight – an almost dream-like nether world caught in time as Nature reclaims these forms. Since in 'real life' matter seldom moves in such mysterious ways, we have arrived at two possible explanations for what is seen: it is actually a thoroughly ordinary setting, transformed by an audience who have collectively ingested some interestingly psychotropic drug or it is just one of those things that can happen whenever some place is well photographed.

CHRIS KILLIP 1973

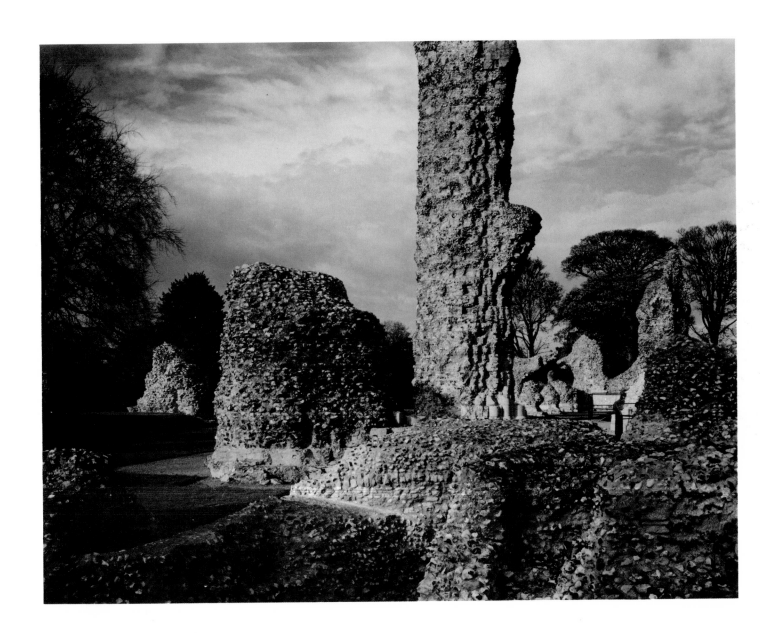

The primary function of newspaper colour supplements is to act as vehicles for advertising; in order to do this effectively they must entertain. The majority of features are 'soft', easily consumable, and unlikely to disturb or offend the readership. Weightier photojournalistic articles are rare and are usually from foreign parts, relating less directly to our own culture and situation. Consequently they are less controversial.

It is of course difficult to draw a line between social responsiblity and entertainment, but advertising forces the issue. The pressure can be seen clearly if we consider the supplements in relation to commercial television. In television, advertising takes up a statutory maximum 10% of viewing time; in the supplements it seldom occupies less than 60% of the magazine's space. This means that even if an editor fervently wished it, it is most unlikely that supplements could become major vehicles for investigative, socially concerned photojournalism. This is a great shame because, through their massive circulation and considerable prestige, if the colour supplements were to adopt a more vigorously campaigning attitude they could certainly make a more valuable social contribution. Despite these limitations, many fine photographs are still made for the colour supplements.

David Montgomery has consistently worked freelance for the *Sunday Times Magazine* as well as being a highly respected advertising and fashion photographer. His photographs have the knack of appearing simple yet are more than mere illustrations, having a quality that might be described as understatement with flair, an unpretentious clarity and balance.

This picture of two retired English jockeys in a café was taken for a *Sunday Times* article on British influence in the French town of Chantilly, renowned for its lace, and horseracing.

DAVID MONTGOMERY 1975

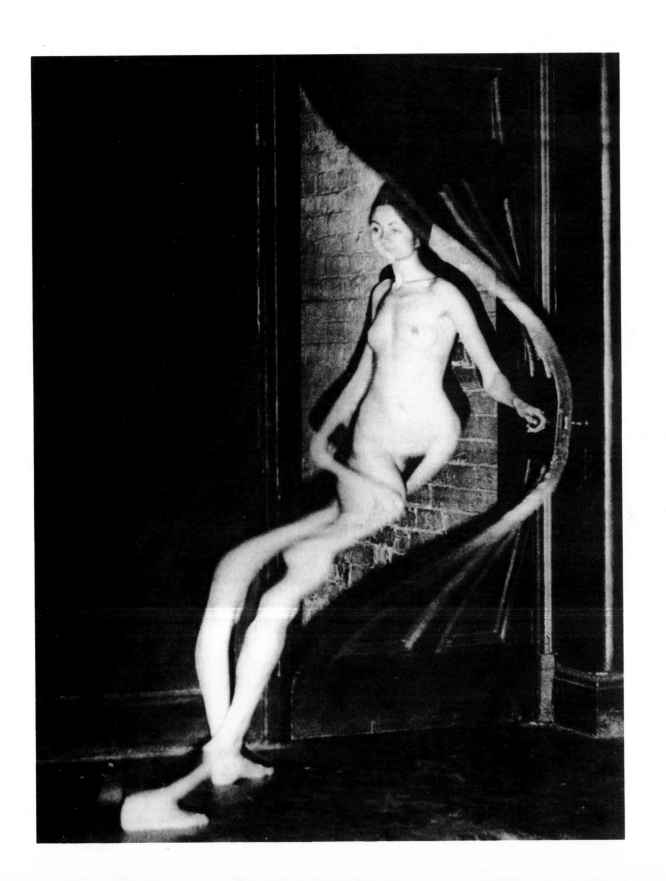

BEGGARS' BANQUET

Client: Decca Record Company Ltd.

Purpose: album sleeve

Subject: sheep and assorted live animals, 5 Rolling Stones, food, clock

Idea: Mick Jagger

Meaning:

Art Director: sacked

Photographer: Michael Joseph

Location: house in Hampstead, property of Church Commission

Conditions: £10 extra charge payable to Church Commission if naked women included

Equipment: Hasselblad Super-Wide, 1 roll 2¼ inch black and white film, Kodalith paper

Aperture: f.32

Subject response: Jagger, 'knocked out'

Client response: used for inner gatefold

Audience response: over 1,000,000 albums sold world-wide

Cost: £1,500

Waste: 60 sheets 10 x 8 inch colour film exposed on same set

Reason not used on cover: typography used instead

Reason taken: after the colour session, '. . . for fun'

MICHAEL JOSEPH 1968

In Victorian Britain posed photographic tableaux were popular. Julia Margaret Cameron and the partners D. O. Hill and Robert Adamson enjoyed posing friends and acquaintances in costumes of varying degrees of absurdity (armour, veils, Greek robes, monks' habits) to produce anything from stylized portraits to re-enactments of classical themes; while O. J. Rejlander and Henry Peach Robinson employed elaborate combination printing techniques to achieve their allegorical tableaux in imitation of Victorian genre painting.

Later in this century the tradition of the dramatic, stylized portrait continued to be refined in the work of Cecil Beaton, Angus McBean and Bill Brandt, while the posed tableaux passed into the province of advertising, producing contemporary fictions on such themes as the bravado released by a box of chocolates, or the social kudos imparted by particular soap powders.

Boyd Webb makes use of the allegorical style of the Victorians and the absurdity often underlying advertising; but, whereas both those forms have specific intents, his are deliberately oblique – some narrative appears to be unfolding, but its meaning does not.

Two men are apparently concerned to understand something about the forms of elephants' trunks, presumably the difference between that of the Indian and African elephant. The caption directs a plausible reading without increasing our understanding, underlining the basic fact that photographs, while describing everything, do not necessarily explain anything.

Our normal perception of photographs is that they are true and self-evident; our expectations, however, often include the convention of captioning. We require that the meaning of a captioned photograph be as readily available as the words are readable and the subject matter recognizable. We are conditioned to this belief by the use of the news photograph and the advertising image, both highly directed and purposeful modes.

Photographs are, in fact, ambiguous fictions; they rely heavily on familiar associations and words to validate their meaning. Captions may resolve any questions we have. In the news media they are used to define an event which the photograph then confirms as fact; in advertising they are meant to convince us of a need which can be filled only by what is pictured. In both instances the captions spell out the understanding intended.

Boyd Webb reverses this process, which ostensibly resolves the photograph's ambiguity, by choosing captions which confound. The specifics of the photograph reveal nothing to help us, though initially they would appear to be our key to a resolution. Consider the same caption applied to other photographs in this book (try it with those on pages 15, 81, 93, 103 or 131). Picture and caption are a reciprocal, enigmatic system.

Photographs are particularly suited to this usage as they so often clearly resemble something, but that is not what they are.

This photograph is only art. It was made in an art context, for art's purposes, to sell itself in the art market-place. It is the product of an ongoing, self-referential, partly state-supported industry, attempting, as with advertising, to convince us how much we need what it provides and, as with news, defining its own existence while confirming it as fact. It is a tenuous existence, but sustained by its believers it has meaning and worth. Of course, as with the diagnostic sciences or selecting a tie, second opinions are mandatory.

BOYD WEBB 1978

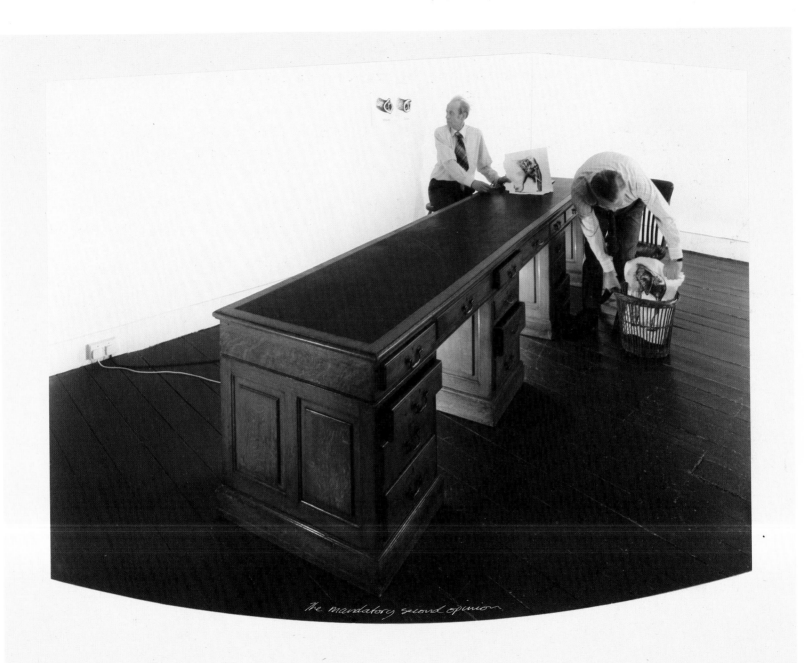

the mandatory second opinion

132 JUMBO HELPS

The ultimate test for a photograph is that it be a sufficiently plausible fabrication to function as truth.

JOHN DRYSDALE 1978

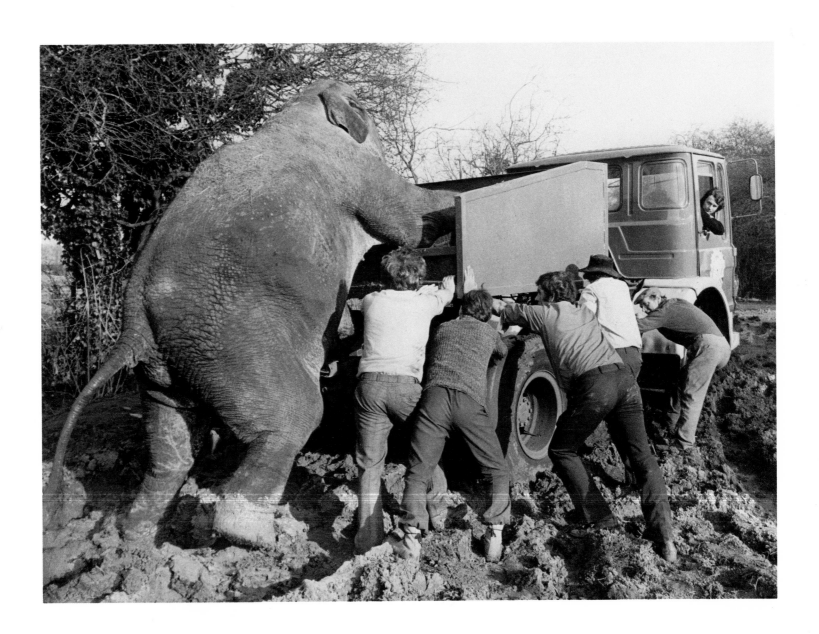

MY CIRCUS PICTURE

From the grainiest and fuzziest to the most seamless and detailed, there is a look to photographs that immediately identifies them as *photographs* – camera-made pictures. In contemporary 'fine photography' the prevalent look is sharp, clear, fully tonal and precisely bordered; yet the photographic process is varied and plastic and may be regarded equally as a print-making medium and as a recordative one.

This picture is a photograph made from a normal negative using a gum bichromate and pigment emulsion process which has the property of becoming less soluble in water the longer it is exposed to light. After exposure through the negative the paper is washed in warm water in order to 'develop' it, dissolving the less exposed areas. The process is extremely amenable to manipulation: recoating, selective washing etc. For this reason, and the fact that it was used at the turn of the century to imitate Impressionist painting, it has been heavily criticized. The prominent English photographer and critic, Peter Henry Emerson, attacked it as impure photography and fake art. Of course, the notion of a 'pure' photography is suspect as virtually any photograph requires some degree of manipulation. The American photographer and impressario Alfred Stieglitz was more astute on this issue: 'The result is the only fair basis for judgement. It is justifiable to use any means on a negative or paper to attain the desired end'.[1]

This photograph was made to record the circus. It has been printed in this way not to imitate turn-of-the-century art but as a reaction to the look of current photography, exploring an alternative to the silver print in presenting the photographic image.

MARI MAHR 1976

Mari Mahr '76.

This photograph should warm the cockles of an ageing Cubist's heart, representing as it does all the surfaces of its subject simultaneously in a single plane. Attempts to do this have been made since the early days of photography. A Cyclograph designed by one Arthur Hamilton-Smith, Keeper of Greek and Roman Antiques at the British Museum, was reported in the *Journal of the Royal Photographic Society* (Vol XIX) in May 1895. Various other techniques have been developed; but the latest and most flexible means of accomplishing this with one negative is the R. E. Periphery Camera.

The result is obtained by rotating the subject in front of the camera while a thin slit, which 'sees' only a sliver of the subject, moves, electronically synchronized, across the film plane, laying down a continuous photographic image – the optical equivalent of an inked printing cylinder turning across a page to leave its imprint.

Because of limited depth of field, the camera's greatest usefulness is in photographing cylindrical objects. It can be of assistance in areas such as archaeology, when a photograph of a rare item, showing all its surfaces, may be sent in lieu of the thing itself. The current practical usefulness of photographing human beings in this manner is dubious; future applications, however, may be imagined (e.g. in criminology, diagnostic medicine, etc.).

The photograph is of Mr Freddy Fox, appropriately the designer of the R. E. Periphery Camera and apparently cylindrical.

FREDDY FOX 1967

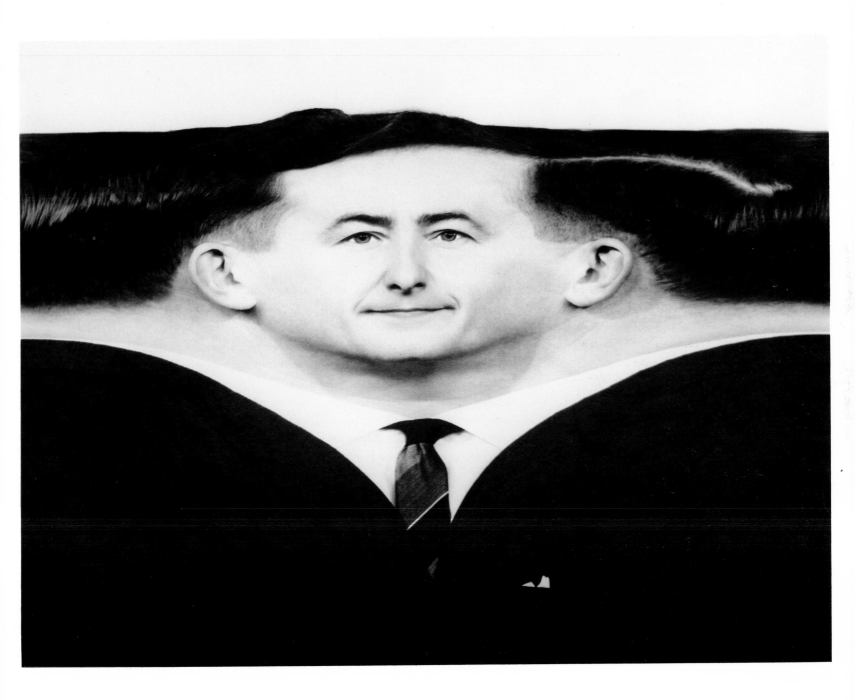

138 FLYING DUCKS

Advertising photographs are among the most ubiquitous and costly of all photographic images. A national poster campaign can ensure that, with the exception of the monastic, the imprisoned, the bedridden and the blind, virtually everybody in the country will see the photograph promoting the product. More than £20,000 may be spent on a single photograph even before posters are printed or media-space purchased. Such work is often manipulative, socially discriminatory (classist, sexist, racist) and technically superb. As imagery it is also frequently dull, a form of visual effluent that enters the consciousness solely by virtue of blanket exposure.

The Benson and Hedges 'Special Filter' cigarette advertising campaign has produced a more interesting set of photographs, the most successful of which rely largely on exploiting ambiguity. In an intriguing and entertaining way they explore ideas about photographic representation, playing with different means of disguising the product instead of simply thrusting it in front of us. The only caption is the statutory government health warning; we are encouraged to examine the image to discover the product's identity/ies. The success of the campaign relies on the viewer being sufficiently intrigued to enter into this game and recognize each new poster as 'another Benson and Hedges ad'.

In a photograph like this – where the mirrored packets transmute to plaster ducks (an oddly down-market reflection), values reverse and realities shift; the cigarettes are clearly not what they seem. An embedded implication is that we are being offered an alternative experience, an unusual hallucinatory reality . . . not carcinogenic death.

ADRIAN FLOWERS: Photographer 1978

GRAHAM WATSON: Art director

GUY HODGKINSON: Set builder

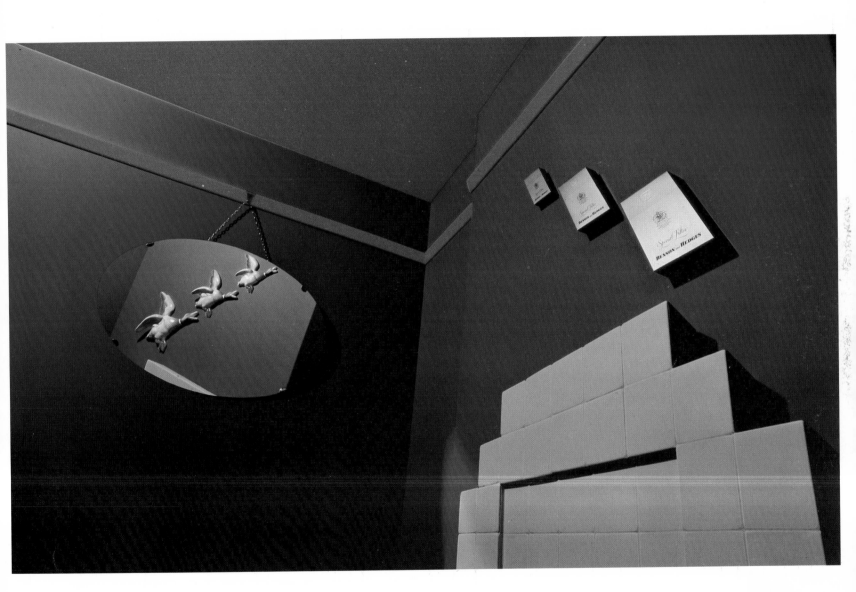

The contentious issue of subjectivity in photography is perennial. In the medium's early days it gnashed its teeth on the relationship between photography and Art. If photography could indeed be subjective then it was argued it could also be Art – but if purely mechanical then it obviously could not be.

Since those days the stubborn monster of subjectivity continues to raise its head in various forms, while the tedious Art/Photography debate drags on. The most publicised recent (though not actually new) formulation on the matter created the categories Mirrors and Windows[1]: Mirrors reflect the individual reality of the photographer and therefore look inward, subjectively, while Windows look outward to describe the external, objective world. The concept has the seductive reasonableness of assertions like 'Every picture tells a story' and 'The camera never lies', but its usefulness is just as suspect. Neither category is absolute. All photographs are to some degree Windows and Mirrors. Cameras record; human choices determine how. But how is this dimension to be scored? What criteria are used to decode a photograph for meaningful objective and subjective content?

Subject matter is a tempting guide: trees, rocks, nudes, clouds and abstract forms have all come to be identified with a personally reflective intent, yet they are only categories of recordable material, with no special claim to be interpretative.

Image quality is another, as fine quality may be associated with care and, by extrapolation, personal involvement and hence subjectivity; alternatively, it may be a blind obsession with photographic technique as a substitute for content.

Mastery of the formal organization of the picture may suggest a desire to say something with that ability or may merely be an indulgence in visual gymnastics.

Stage-managed photographs deal with a fabricated rather than found reality, a world which can be created in the recesses of the photographer's imagination. Yet their most frequent use is in advertising, where they are usually made to an art director's specifications for a client's selling requirements, with the photographer playing a subordinate role.

Unusual photographs may reflect an unusual mind behind the camera transmitting a 'personal vision', but the quality may also be due to our own unfamiliarity with their subject matter or some recent pictorial fad (e.g. blurring, tilting, daylight flash, decapitation, inversion, etc.).

Titles and captions accompanying photographs may well indicate how the photograph is meant to be seen, but knowledge of the photographer's intent is not sufficient for a meaningful understanding of the image if the photograph itself is not a successful collaborator. While added words can give a context in which to read the image they are not a substitute for content and can even be at odds with the photograph's purposes and capability. Furthermore, many photographs have only nominal titles or none at all, and offer no verbal clues to their relative subjectivity or objectivity.

The public stance of the photographer can be considered as well, as some individuals make claims of subjectivity for their work while others plead objectivity, and this may affect the way we approach the work (though, again, claims and photographs may disagree); yet those who make no such statements may, in practice, operate with equivalent concerns.

And there is the unpredictability of the viewer, whose frame of reference may be far removed from that of the picture-maker and whose responses will flow from a personal set of experiences, meanings and symbols. The photograph lives in this interaction and its ultimate meaning – subjective and objective – is here, to some extent, thrown up for grabs to be redetermined and defined as you choose.

All these proposed criteria for isolating or measuring subjectivity in photography ultimately fail. There is no question of photography's role as a primary twentieth century art; what is important is recognizing that precisely the functional presence of both objective *and* subjective concerns make photography so effective a medium.

This makes the equation nearly complete: the camera records and human choices determine how. Human choices also decide what to make of the result. But there is still one missing factor, continually affecting the outcome.

We should like to draw your attention to the photograph to the right. It represents the final quantity, the extra dimension of Chance. It is an accident, one of the waste exposures on a roll of 35 mm film as it is loaded into the camera and advanced to 'frame 1', the point at which picture-making is consciously intended to begin. And so, as chance would have it, it has virtually nothing to do with any of the things we have been discussing here.

PHOTOGRAPHER IRRELEVANT [2]

'Nuclear particle physicists are searching for the secrets within the heart of subnuclear matter in an attempt to understand Nature herself. These physicists produce beams of high energy particles and fire them at various targets. By studying the "fragments" which are produced in these energetic collisions, it is hoped to piece together the highly complex jigsaw puzzle of life'.[1]

This is the calligraphy of subnuclear physics; the signs that must be decoded to learn their meaning. It is a photograph of the inside of a 'bubble chamber' containing a mixture of liquid hydrogen and neon maintained under pressure. A beam of neutrino particles enters from the left. The paths of the charged particles produced by a collision are made visible by lowering the pressure of the chamber, causing bubbles to form along their tracks. A magnetic field acts over the whole chamber, causing positive and negative particles to bend in opposite directions. Uncharged particles, including the neutrinos themselves, are not visible; but some, such as gamma rays (dotted in drawing), are visible when they change into oppositely charged electron pairs . . . as seen in the photograph.

Thousands of such photographs are taken, and tracings made of the significant information. At the same time the photographs can be scanned automatically and the results fed into a computer for detailed analysis of each interaction. The problems of arriving at this particular photograph are enormous; neutrinos are remarkably elusive. Indeed, their mass at rest is theoretically zero. They interact with matter most infrequently: only 1 in 10^{10} (100,000,000,000) that pass straight through the Earth is likely to meet a particle. With an estimated 10^{14} neutrinos from the Sun passing through our bodies every second, only one neutrino interaction will occur in a lifetime.

The world of subnuclear physics is one of statistical probabilities, leaning on chance for the meaning it yields. It seems appropriate that the last photograph in this book serves as the interface between a chance event of which only the recorded traces can be seen and an effort to 'piece together the highly complex jigsaw puzzle of life'.

But if that does not seem appropriate to you, consider this: if all of you spend the next two weeks carefully perusing this book, one of you should have a neutrino interaction.

RUTHERFORD LABORATORIES 1978

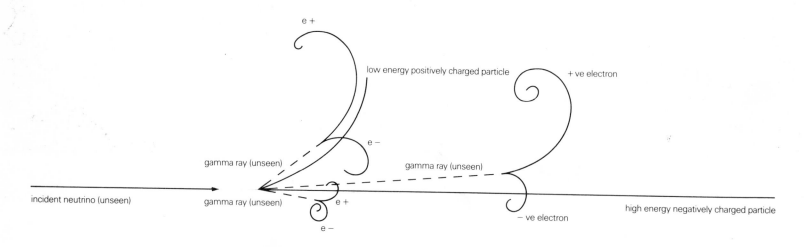

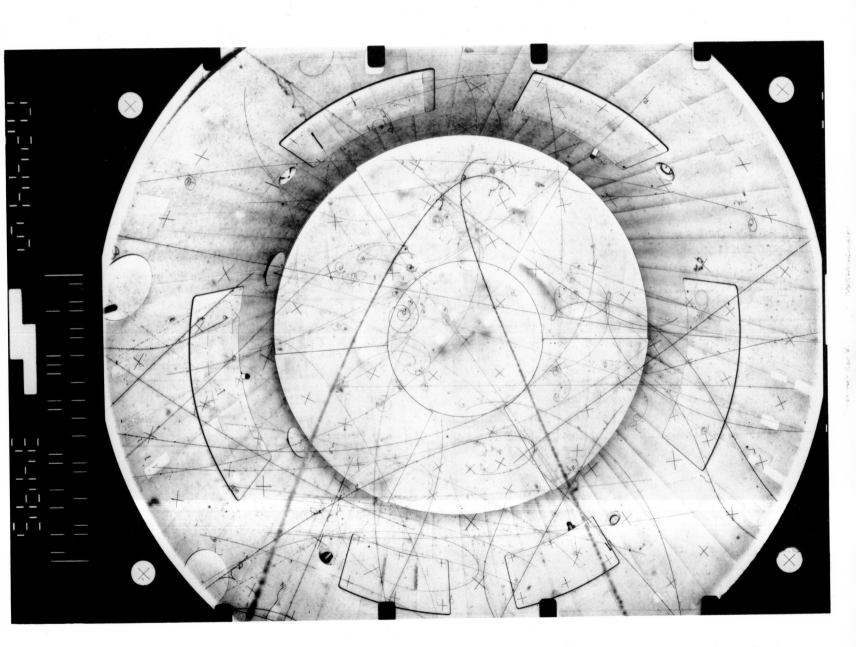

1 Arthur Tress, *Album* 2, March 1970, p.1.

2 Mandala – Sanskrit word for 'circle' or 'magic circle', but commonly refers to a square or rectangular shape divided into various sections, or 'courts'. In Hindu and Buddhist Tantraism, a holy precinct prepared in honour of a divinity and sometimes used for the performance of a sacred rite. It is also a representation of the cosmos, a consecrated area in which the forces of the universe are collected.
In Japan, there are two mandalas: the 'diamond world' and the 'womb world' of the Shingon sect, both representing the whole of the universe. In both the solar divinity occupies the central position, of which all surrounding divinities are but aspects. In the 'diamond world', movement tends to be inward, toward unity; in the 'womb world' it is outward from the centre, from unity to the many.
(Information largely from *Encyclopaedia Britannica*.)

3 C. G. Jung, *Man and His Symbols*

4 Jung identifies four levels to the anima's development: the first, the primitive Earth Mother, instinctive and sexual; the second, romantically beautiful; the third, spiritual love and devotion; the fourth, transcendental wisdom – they are not mutually exclusive.

5 *Summer Show 4* Serpentine Gallery exhibition catalogue, Arts Council of Great Britain, London 1977

1 From *The Work of Hipgnosis 'Walk Away Reneé*, Paper Tiger, London 1978

1 Male Chauvinist Pig

1 Nikolaus Pevsner, *The Buildings of England: Suffolk*, Penguin Books, London 1961

147 INDEX